DOVER MASTERWORKS

Color Your Own
DEGAS
Paintings

Rendered by Marty Noble

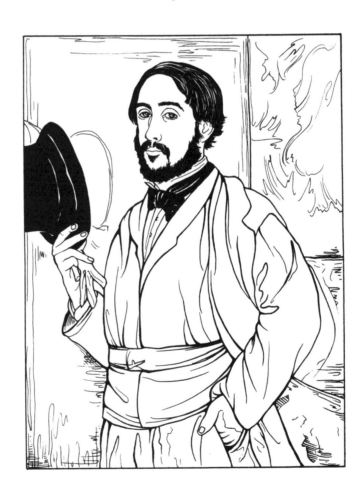

D1377925

DOVER PUBLICATIONS, INC.
Mineola, New York

Bibliographical Note

Dover Masterworks: Color Your Own Degas Paintings, first published by
Dover Publications, Inc., in 2014, is a revised edition of *Color Your Own Degas
Paintings,* originally published by Dover in 2002.

International Standard Book Number

ISBN-13: 978-0-486-77941-6
ISBN-10: 0-486-77941-6

Manufactured in the United States by RR Donnelley
77941603 2015
www.doverpublications.com

Edgar Degas
(1834–1917)

Hilaire-Germain-Edgar Degas was born in Paris, France, on July 19, 1834. He came from a wealthy family with banking and business connections in both Italy and the United States. Degas studied law after receiving his degree from the Lycée Louis le Grand, but pursued a career in painting instead. He enrolled at the École des Beaux-Arts and also studied privately with a pupil of the painter, Ingres. He taught himself to paint by copying old masters in the Louvre, and also visited art museums during his travels to Italy in the 1850s. During this time he focused on painting portraits and historical subjects.

Upon his return to Paris in 1859, Degas became friendly with fellow artists such as Whistler, Legros, Courbet, and Manet. An avid art collector as well, he began to take an interest in painting modern life subjects. Much of his art is fixated on indoor figure groups of musicians and stage performers. Subtle movements of these performers are painted in elegant, painstaking detail.

Degas is best known for his paintings of ballet dancers, circus performers, and horse races. These kinds of subjects afforded him the opportunity to depict fleeting moments in time and unusual angles, such as in *Miss La La at the Cirque Fernando* (see plate 29). Akin to the view through the lens of a camera, Degas's paintings are infused with novel, unique perspectives that have come to epitomize his work.

Degas worked primarily in oils and pastels, and in the 1880s, with failing eyesight, he explored sculpture. He created a group of small bronze sculptures of dancers, bathing women, and horses, which again revealed his special ability to capture the ordinary, unobserved movements of figures. Toward the end of his life, Degas experimented with photography and also wrote poetry. He died on September 27, 1917.

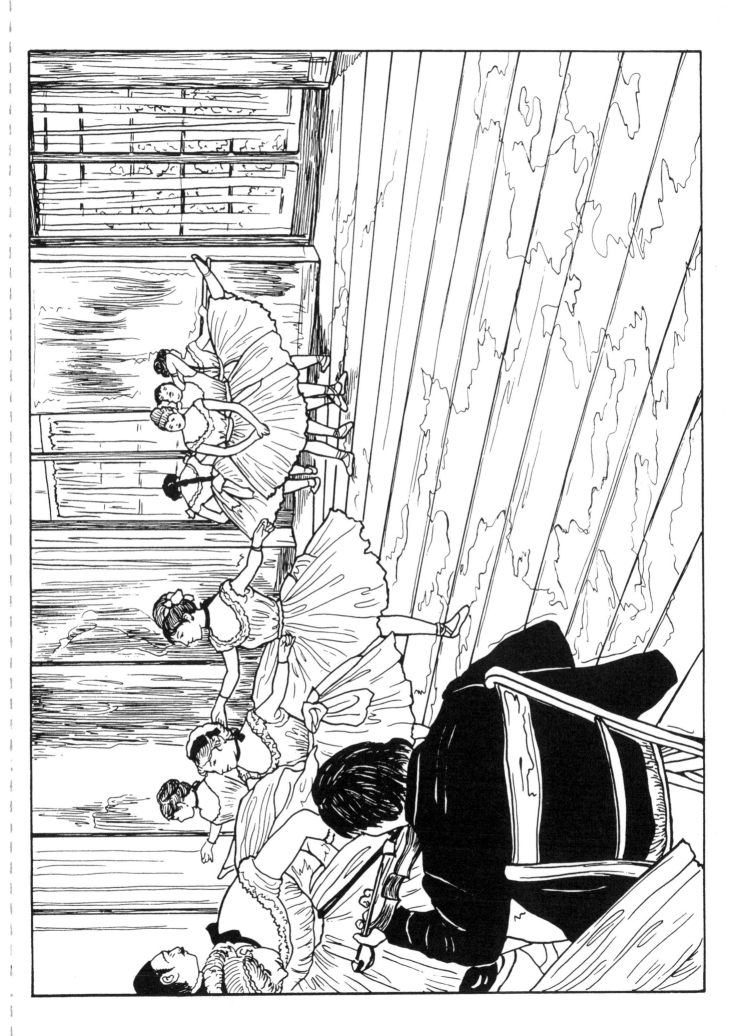

Plate 1
EDGAR DEGAS (1834–1917)
Dance School, 1874
Oil and tempera on canvas.

Degas spent a lot of time at the Paris opera house, in the audience as well as backstage and in the dance studios. Ballerinas were the artist's favorite subject, and he painted them thousands of times over the course of his career. In a letter to his friend, the art dealer Ambroise Vollard, he once said, "my chief interest in dancers lies in rendering movement and painting pretty clothes."

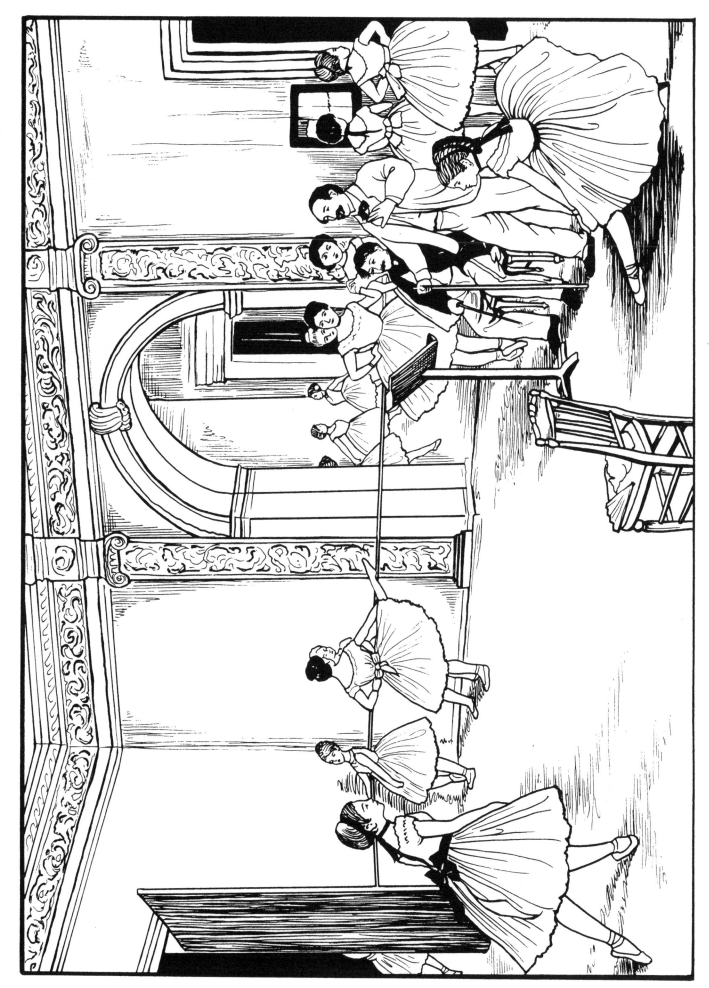

Plate 2
EDGAR DEGAS (1834–1917)
The Dance Foyer at the Opera, 1872
Oil on canvas.

The Dance Foyer at the Opera is Degas' first large-scale work featuring dancers. The artist's choice of composition—the middle of the room is left open, as if the dancer on the left were about to make her way into it—gives the viewer the feeling of being a witness to a fleeting moment in time.

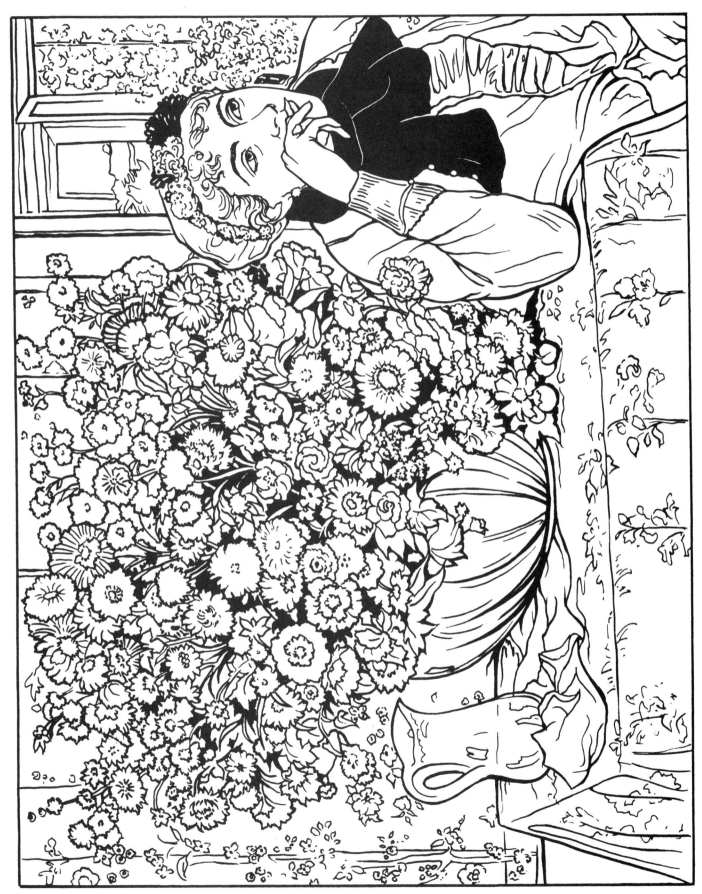

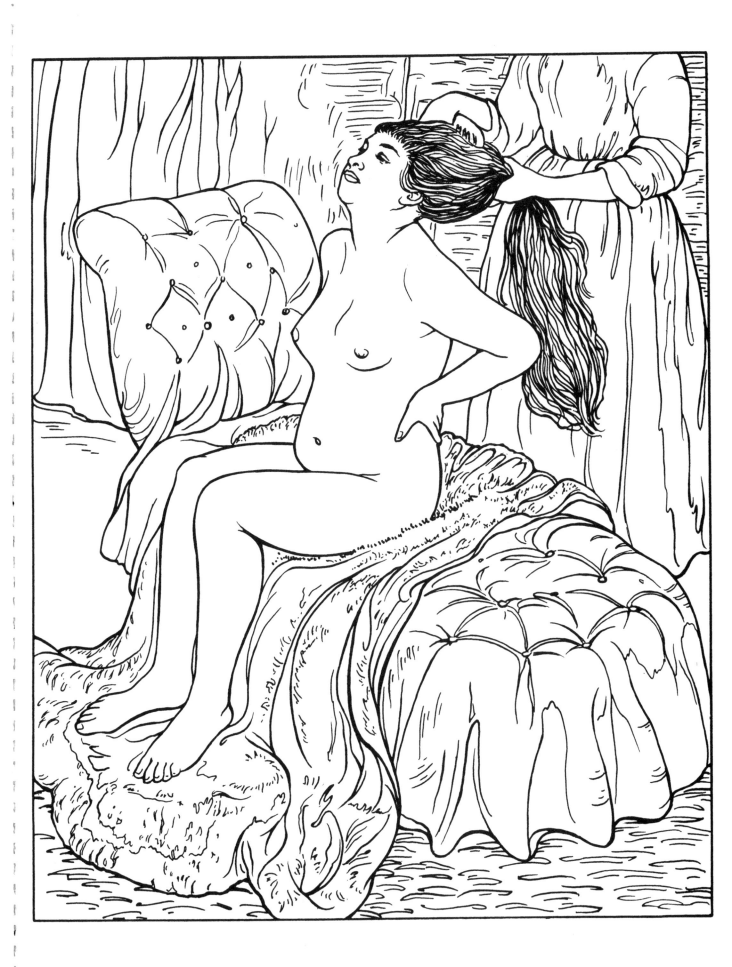

Plate 4
EDGAR DEGAS (1834–1917)
A Woman Having Her Hair Combed, 1886–88
Pastel on paper.

Although usually remembered for his images of dancers, Degas often painted pictures of women bathing, dressing, and otherwise getting ready for their day. Critics agree that *A Woman Having Her Hair Combed* was probably created for the 1886 impressionist exhibition, but for reasons unknown, it never made it into the show.

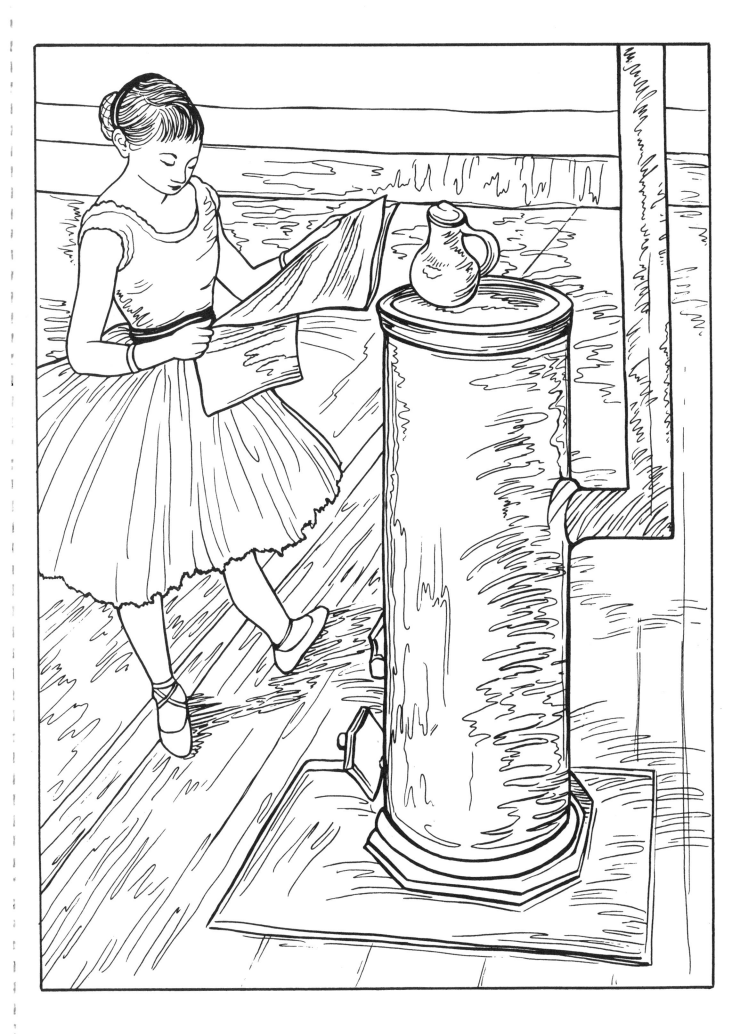

Plate 5
EDGAR DEGAS (1834–1917)
Dancer Resting, c. 1879
Pastel.

The subject of this painting is Marie Geneviève van
Goethem, a dancer with the Paris opera who posed for
Degas on several occasions. Little is known about the
young Marie, except that she was from a poor family and
joined the ballet at age thirteen in order to earn some
money. It is likely that Degas paid her a small sum each
time she modeled for him.

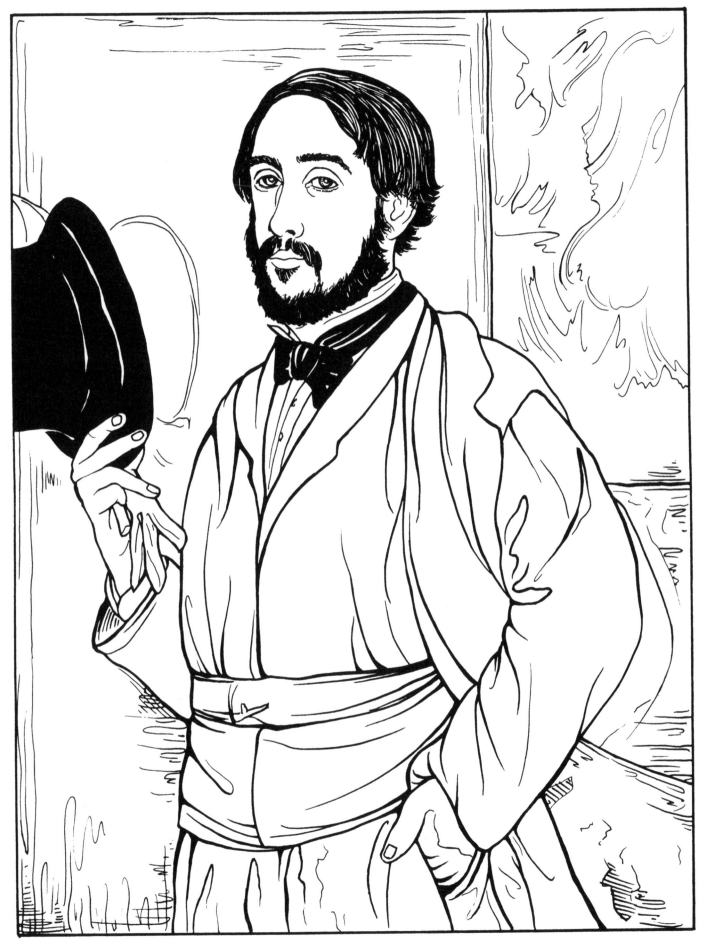

Plate 6
EDGAR DEGAS (1834–1917)
Self-Portrait (Degas Saluant), **1863**
Oil on canvas.

Degas created more than forty self-portraits throughout his lifetime, most of them early in his career. In this 1863 work, Degas depicts himself with an informal attitude, greeting the viewer with a wave of his hat.

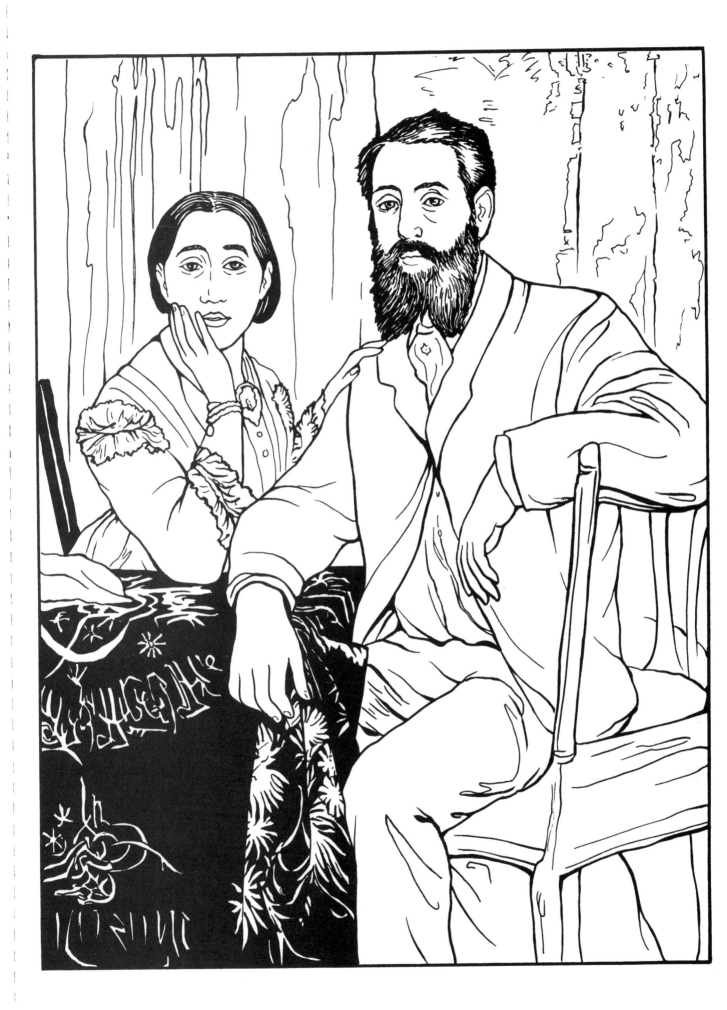

This work features Degas' sister Thérèse with her husband, Edmondo Morbilli. The couple lived in Naples, but came to visit Degas in Paris on several occasions. This work was painted shortly after the couple lost a child, and critics generally agree that this may be the reason for the worried expression on Thérèse's face.

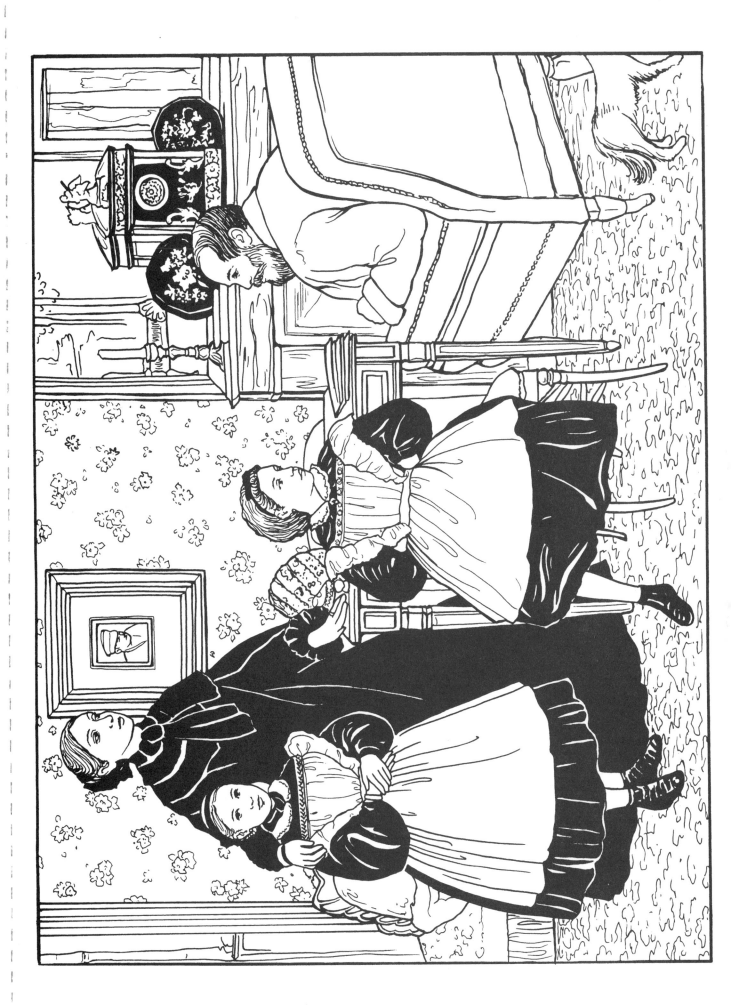

Plate 8
EDGAR DEGAS (1834–1917)
The Bellelli Family, 1860–62
Oil on canvas.

Perhaps the best known work to come out of Degas' early career, this family portrait features the artist's aunt Laura, her husband Gennaro Bellelli, and their daughters Giulia and Giovanna. This composition was completed from a series of sketches Degas made while visiting their home in Florence, Italy in the late 1850s. Laura Bellelli is dressed in black to mourn the passing of her father, who died shortly before Degas' visit.

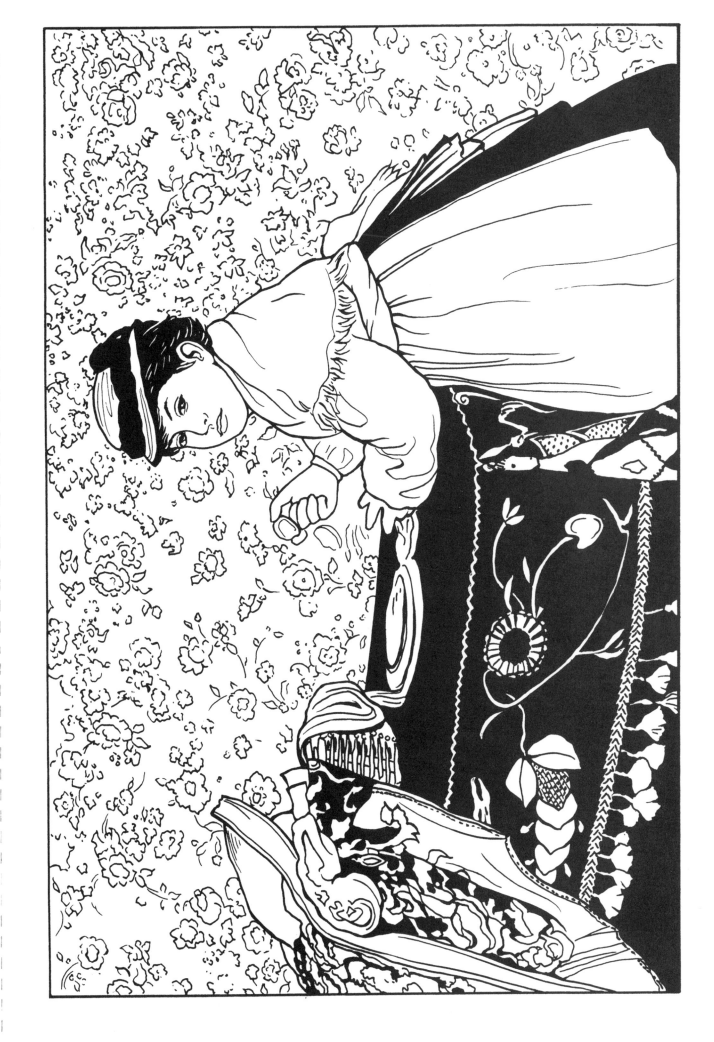

Plate 9
EDGAR DEGAS (1834–1917)
Hortense Valpinçon as a Child, 1869
Oil on canvas.

Degas often visited the home of his childhood friend, Paul Valpinçon, in Normandy. During these visits, members of the family were more than willing to pose for the artist. This image of Hortense Valpinçon, the eldest daughter and only girl of the family, was completed on a scrap of old mattress because Degas had forgotten to bring canvas with him to Normandy.

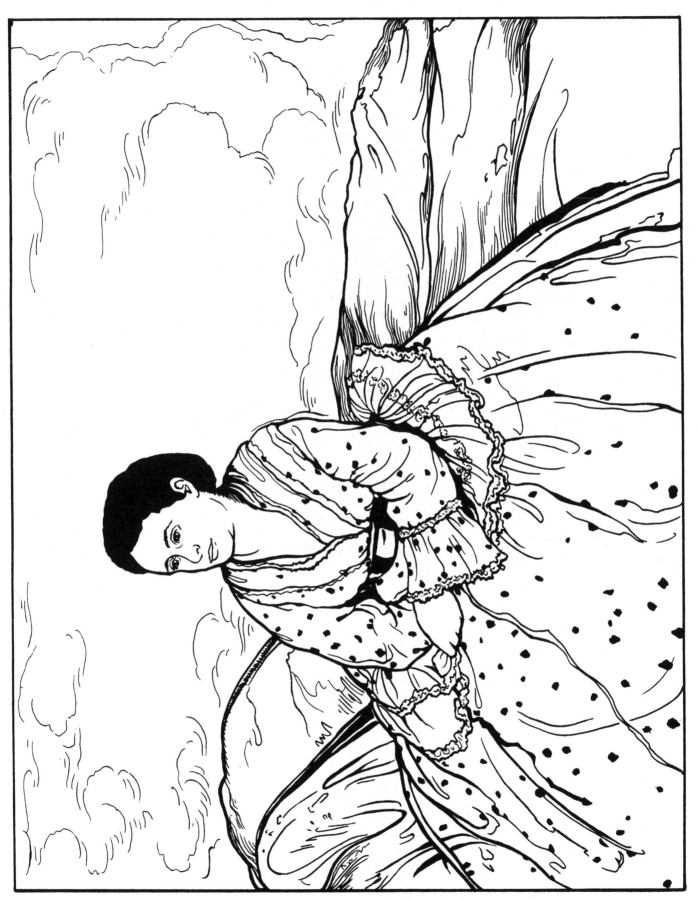

Plate 10
EDGAR DEGAS (1834–1917)
Mme. René De Gas, 1872–73
Oil on canvas.

The woman in this portrait is Estelle De Gas, the American-born wife of the artist's brother René. At the time this work was completed, Estelle was almost completely blind. It was around this time that Degas was beginning to notice his own eyesight weakening, and critics suggest that the soft but indistinct tones chosen for this painting are indicative of Degas' feelings of compassion towards Estelle.

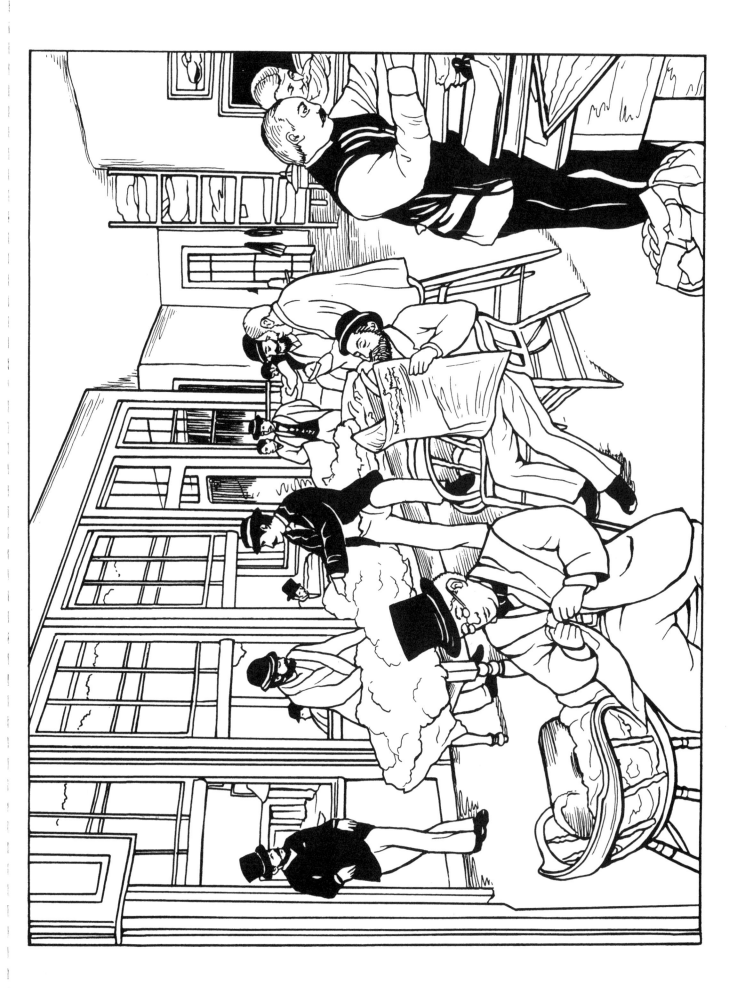

Plate 11
EDGAR DEGAS (1834–1917)
The Cotton Market, New Orleans, 1873
Oil on canvas.

The Cotton Market, New Orleans was the first of Degas' paintings to be purchased by a museum, thus marking a turning point in the artist's career. The painting shows Degas' uncle, Michael Musson, at the very moment that he learned his cotton brokerage was bankrupt due to an economic crash. Michael Musson is the man in the center of the work, reading the newspaper.

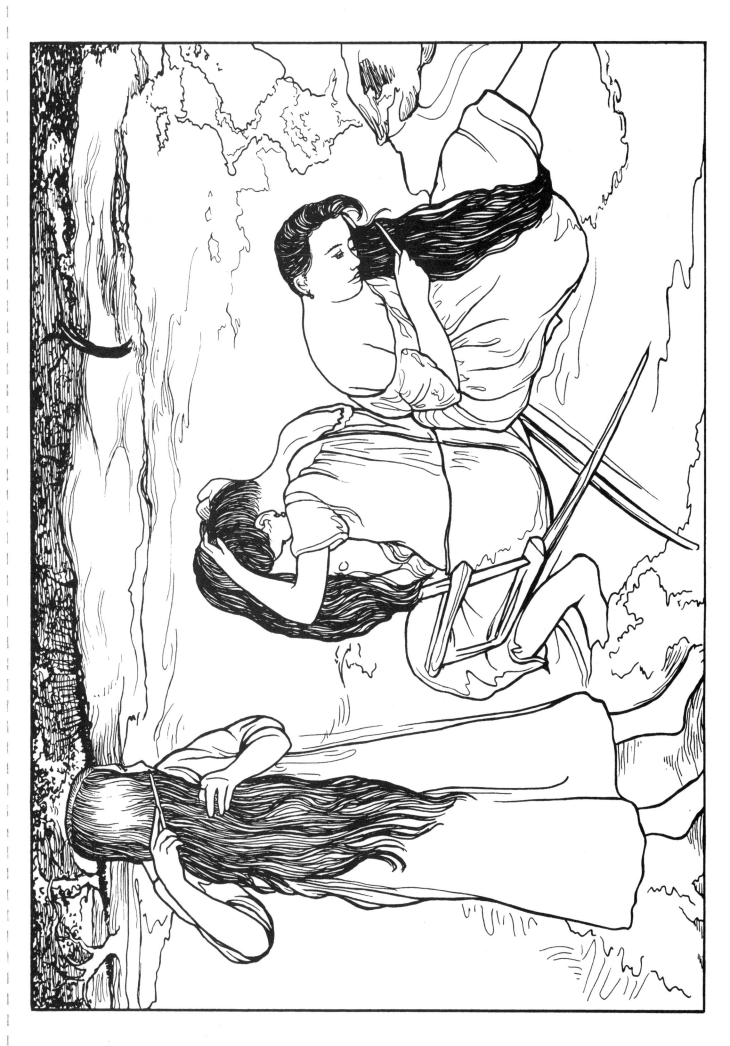

Plate 12
EDGAR DEGAS (1834–1917)
Women Combing their Hair, **1875–76**
Essence on paper.

Degas enjoyed drawing women at their boudoir for the same reason he enjoyed drawing dancers. It allowed him to explore the unusual and sometimes awkward movements that aren't normally applied in other facets of life. It is likely that the three women in this work are all the same model, in different poses.

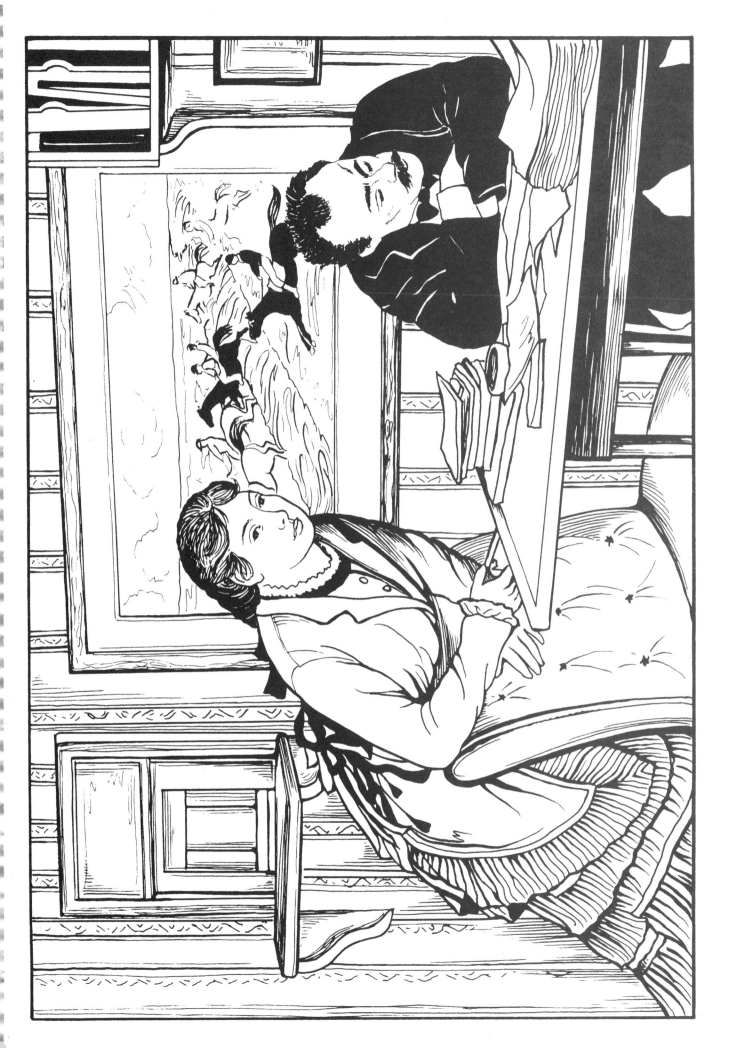

Plate 13
EDGAR DEGAS (1834–1917)
Pouting, 1873–75
Oil on canvas.

The subjects in this painting are the writer Edmond Duranty and the model, Emma Dobigny. Despite being somewhat ambiguous, the scene was probably arranged deliberately by the artist. The fact that the woman does not wear a hat indicates that the two subjects are very familiar with each other—perhaps they are meant to be spouses, or siblings. The cause of the "pouting," however, is up to the viewer to decide.

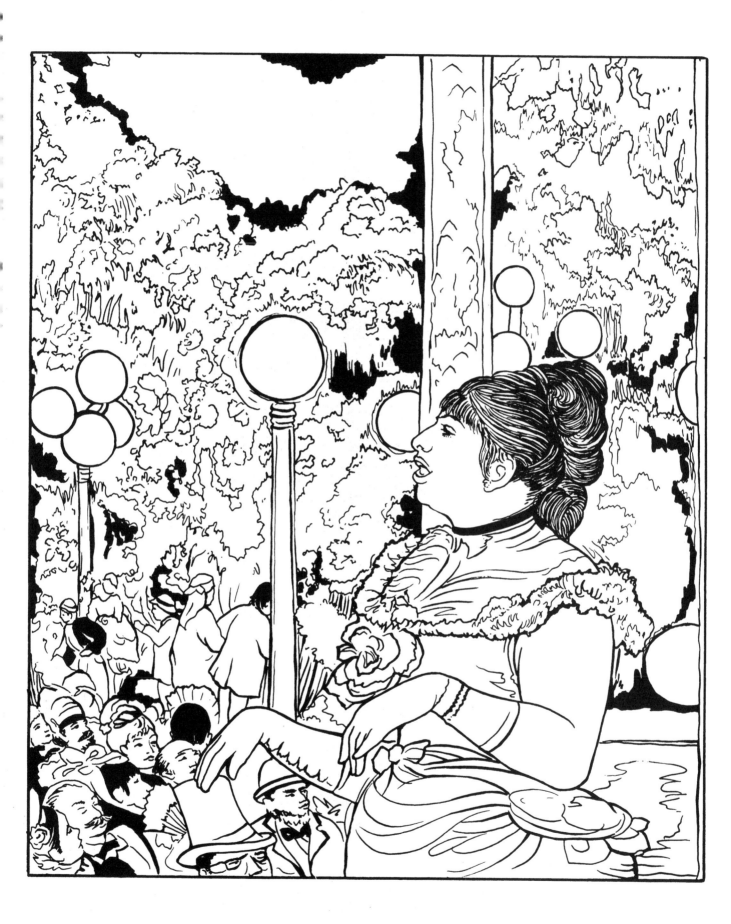

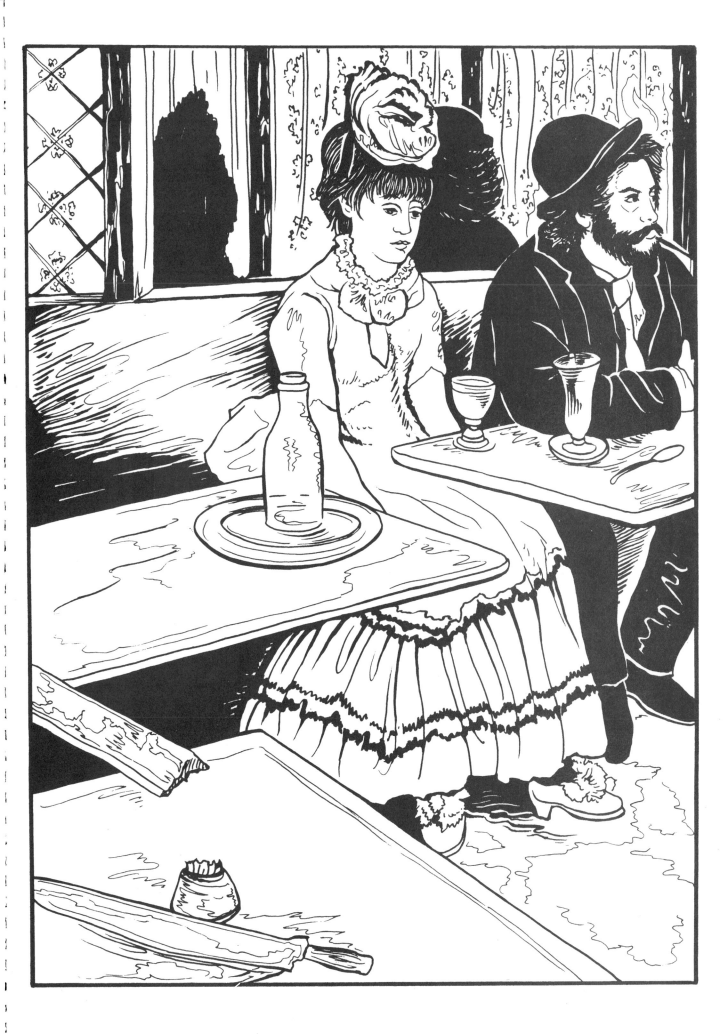

Plate 15
EDGAR DEGAS (1834–1917)
The Absinthe Drinker, 1876
Oil on canvas.

The subjects here are the actress Ellen Andrée and the painter Marcellin Desboutin, both of whom were celebrated public figures during Degas' time. The setting is the Café de la Nouvelle-Athènes, which was a popular gathering place for artists, writers, and other "bohemian" figures of Paris. Degas probably painted this picture with the intent of capturing his subjects at an introspective moment, but the work created quite the stir, with several critics calling it "outrageous" and "disgusting." Degas eventually had to issue a public statement to confirm that Andrée and Desboutin were not alcoholics.

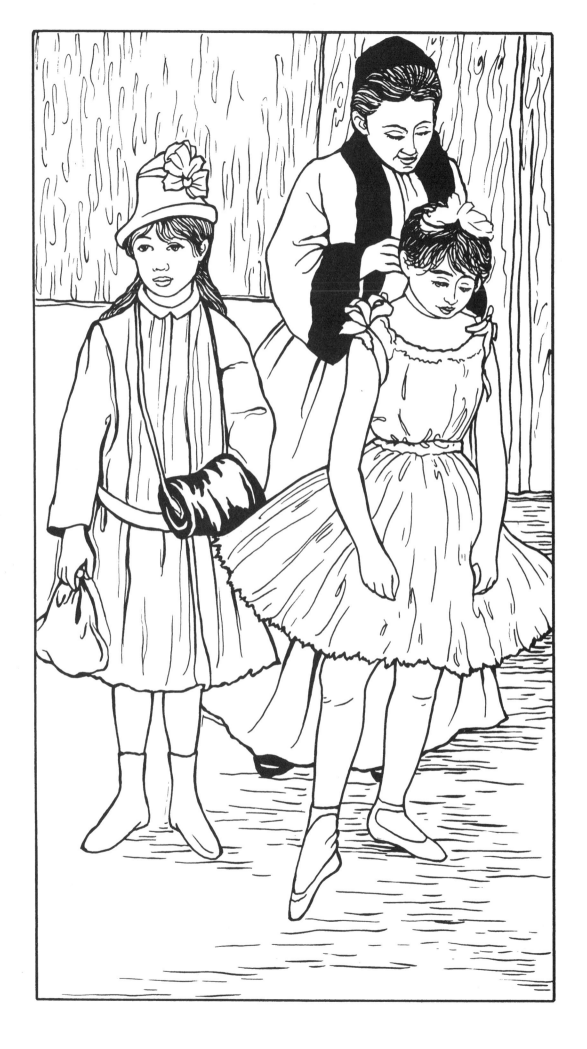

Plate 16
EDGAR DEGAS (1834–1917)
The Mante Family, 1889
Pastel on paper.

This work features two young ballerinas, Suzanne and Blanche Mante, standing with their mother outside an exam room at the Paris opera house. The family lived in the same neighborhood as Degas, and the artist was friends with the girls' father, Louis-Amédée Mante, a double-bass player in the opera orchestra. Both girls were successful dancers, and went on to secure places in the *coups de ballet.*

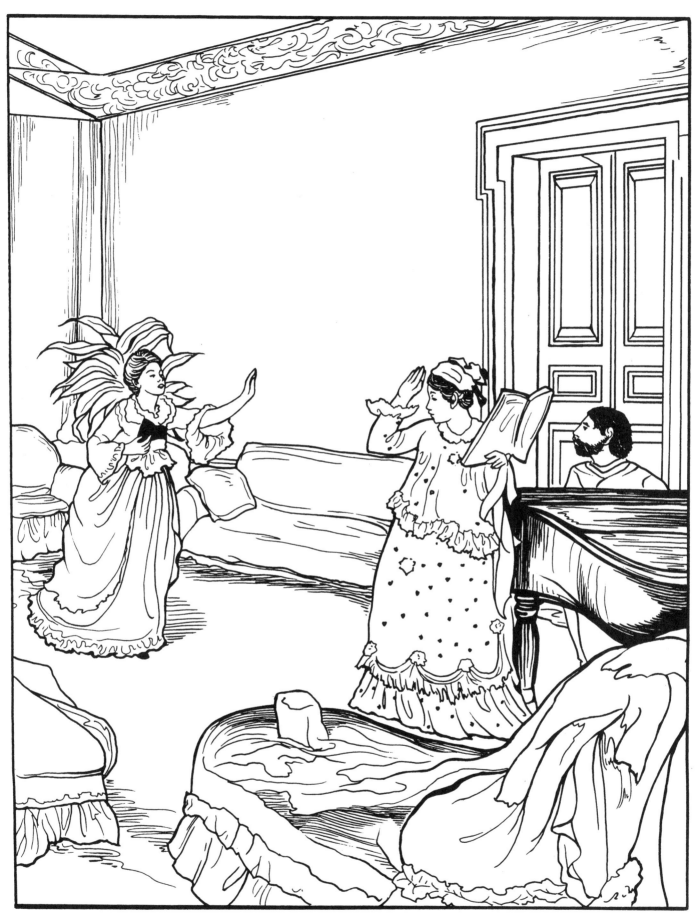

Plate 17
EDGAR DEGAS (1834–1917)
The Song Rehearsal, 1873
Oil on canvas.

The Song Rehearsal was completed while Degas was visiting family in New Orleans. Critics speculate that the women in the painting are the artist's cousin Mathilde and either his sister-in-law Estelle De Gas, or perhaps his younger sister Marguerite. This would have been a casual event, likely taking place in the mid-afternoon, yet the two women are fully absorbed in what they are doing. Both are mimicking the exaggerated gestures of opera singers.

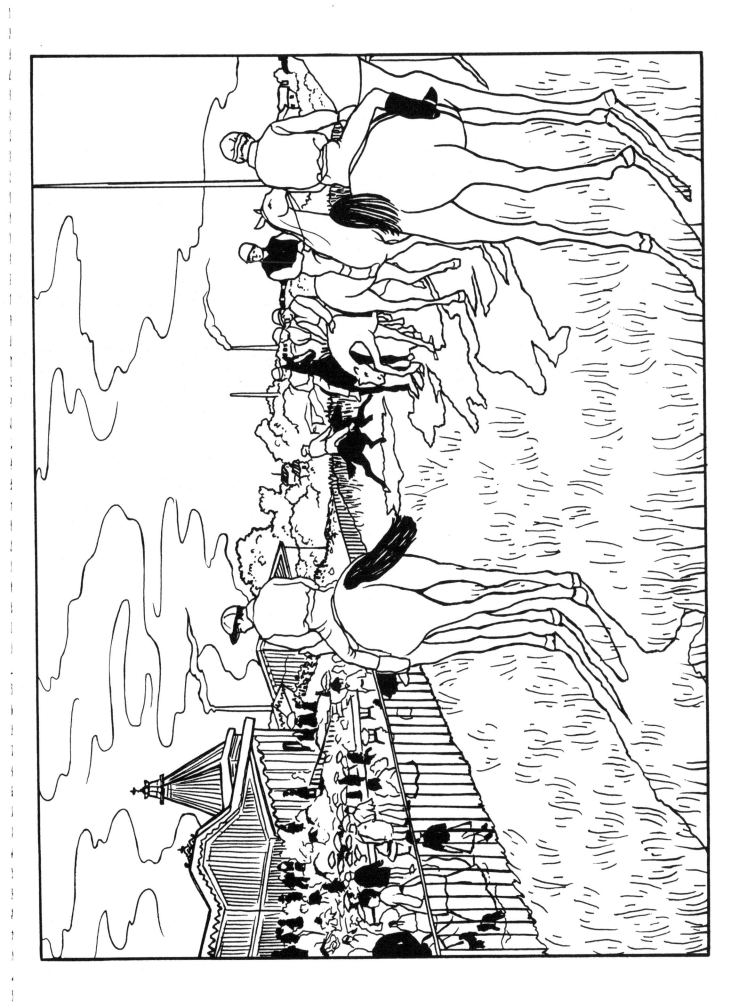

Second only to dancers, the racetrack is a common theme amongst Degas' works. Degas was interested in movement, so the racetrack—a fashionable place for upper-class Parisian society to gather—offered ample opportunity for unique compositions.

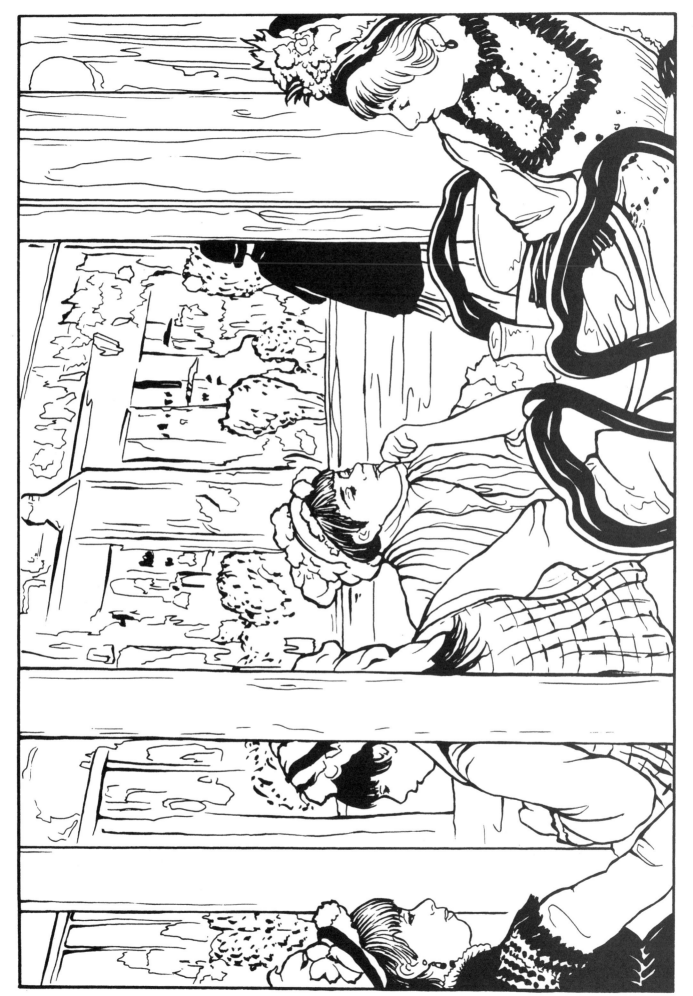

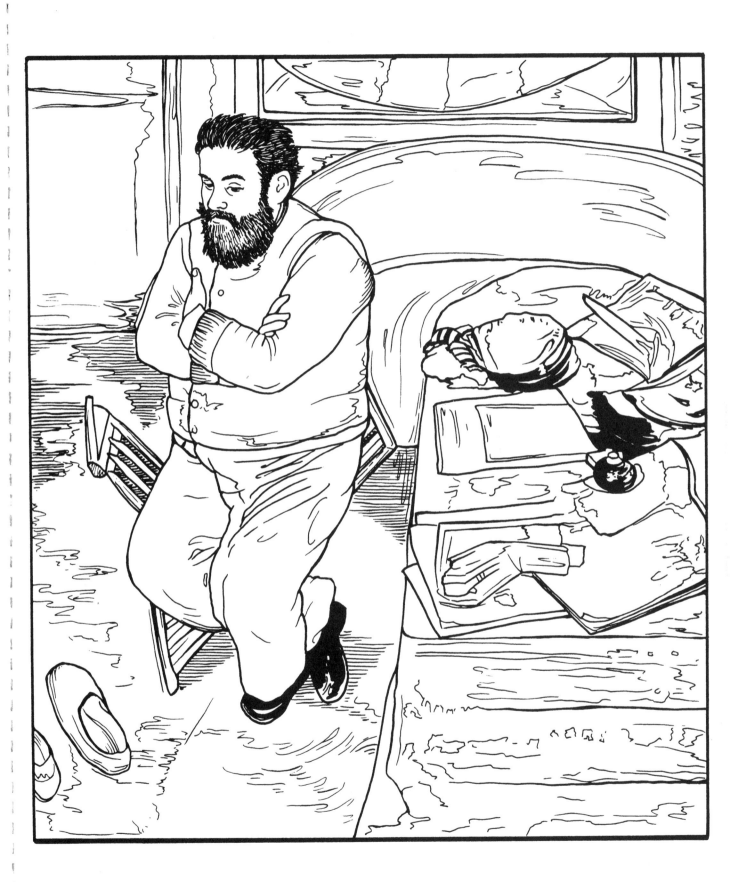

Plate 20
EDGAR DEGAS (1834–1917)
Diego Martelli, 1879
Oil on canvas.

A good friend to Degas, the art critic Diego Martelli is depicted here from an unusual, overhead perspective, as he perches on a wooden stool. In many of Degas portraits, he includes certain objects or background scenery that reveal something about the subject's life. Martelli is shown here with his papers and pipe strewn across the table next to him, and his slippers casually tossed on the floor. This choice in composition was likely related to the subject's relaxed personality.

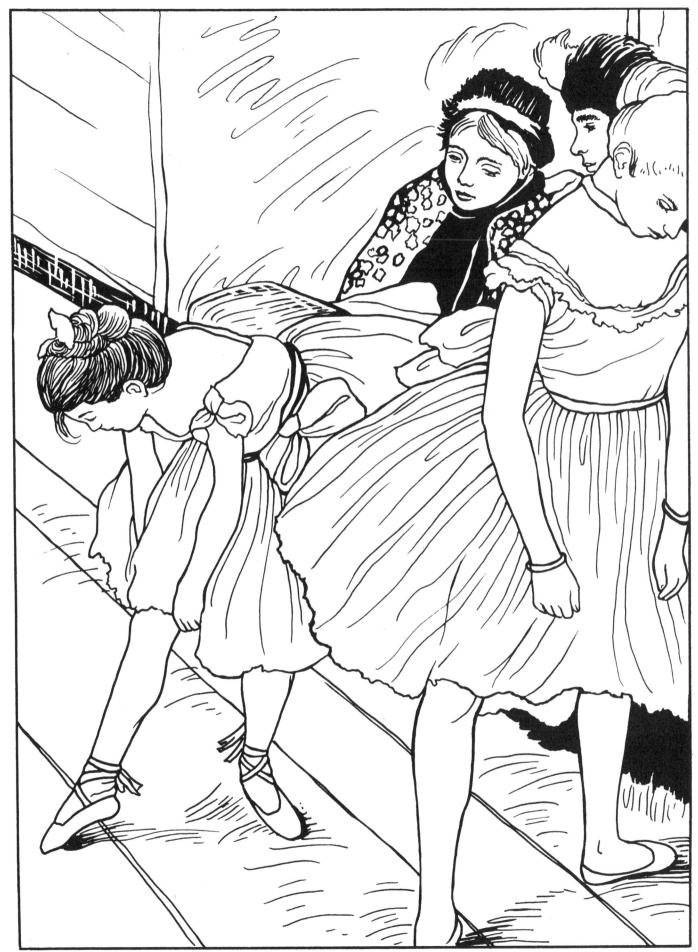

Plate 21
EDGAR DEGAS (1834–1917)
Before the Exam {The Dancing Class), 1880
Pastel on paper.

One of the hundreds of compositions by Degas featuring ballerinas, here we see two young dancers preparing for an exam. Their chaperones, likely older, retired ballerinas, are seated behind them.

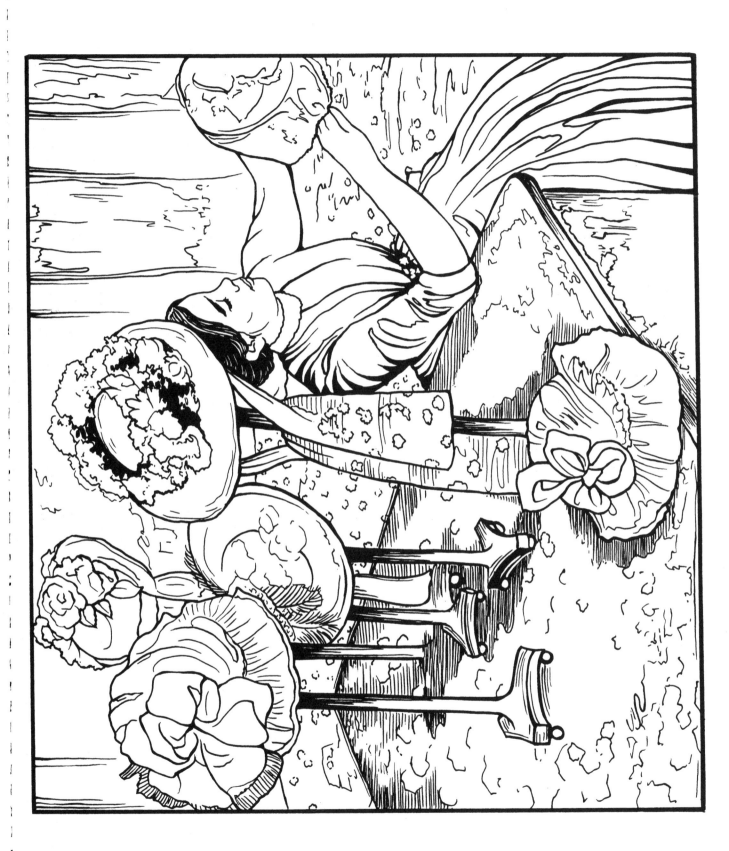

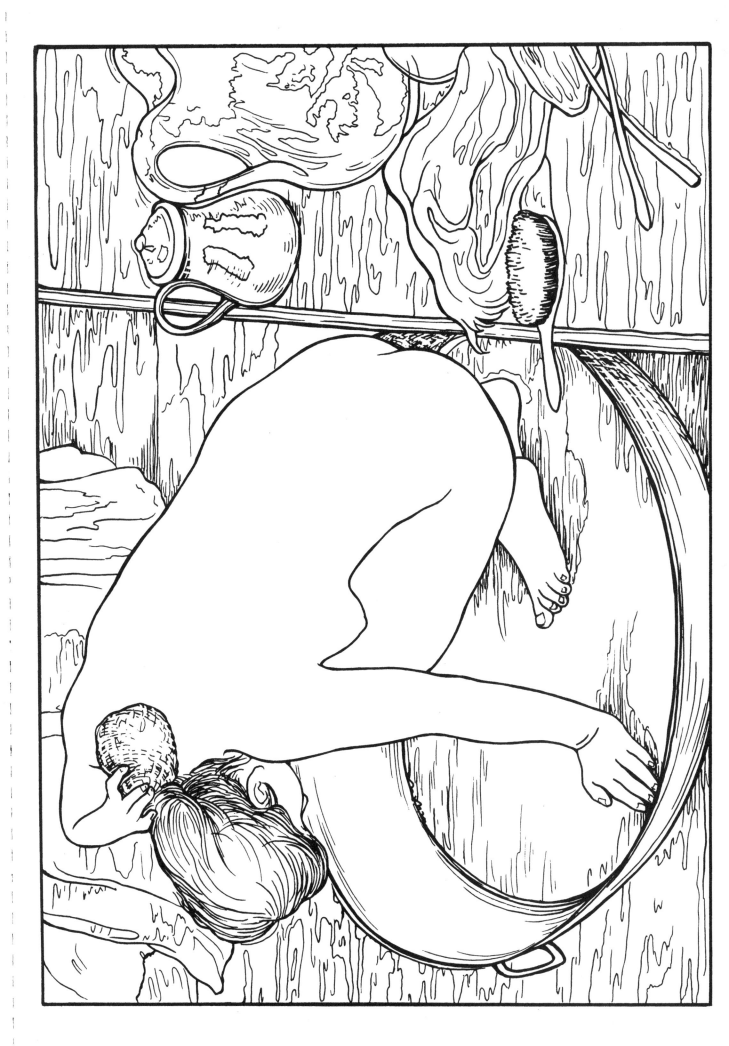

Plate 23
EDGAR DEGAS (1834–1917)
The Tub, **1886**
Pastel on cardboard.

In the mid-1880s Degas created a series of compositions featuring women bathing—a subject which he had already explored several times earlier in his career. Degas' compositions on this theme are interesting as they are not romanticized in any way. In this work, the viewer looks down upon the subject as she crouches awkwardly in order to keep her balance in the small tub.

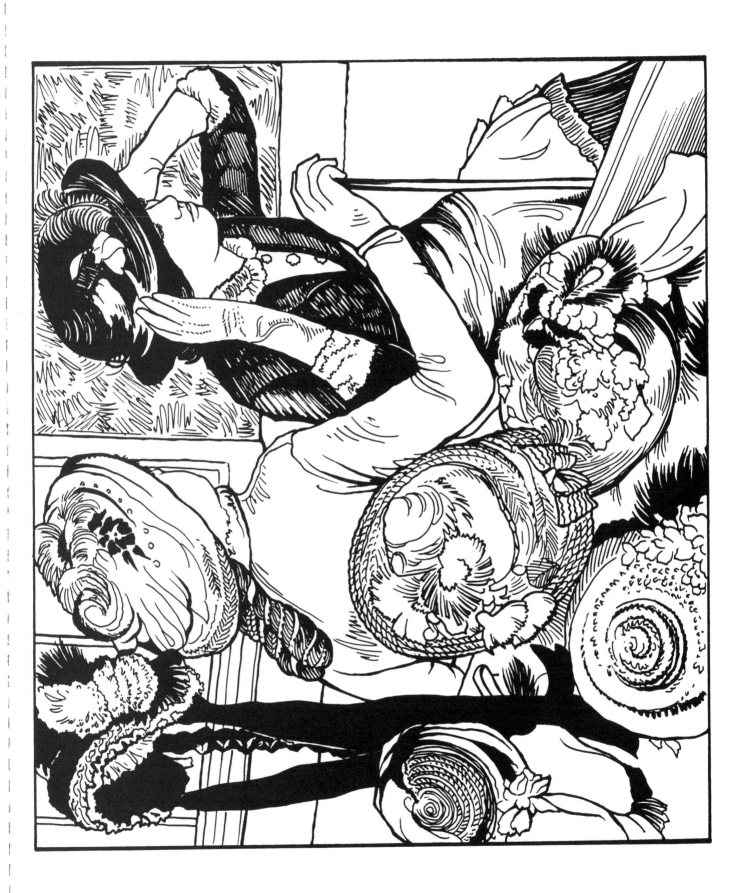

Plate 24
EDGAR DEGAS (1834–1917)
At the Milliner's, 1882
Pastel.

Degas often accompanied his female friends (particularly fellow impressionist Mary Cassatt) to fashion boutiques. Deeply interested in creating images of modern life, Degas completed several works featuring the millinery (hat maker's shop) in the 1880s. In this work, the viewer is positioned behind the counter, where the milliner herself would be standing as she helped the two women try on hats.

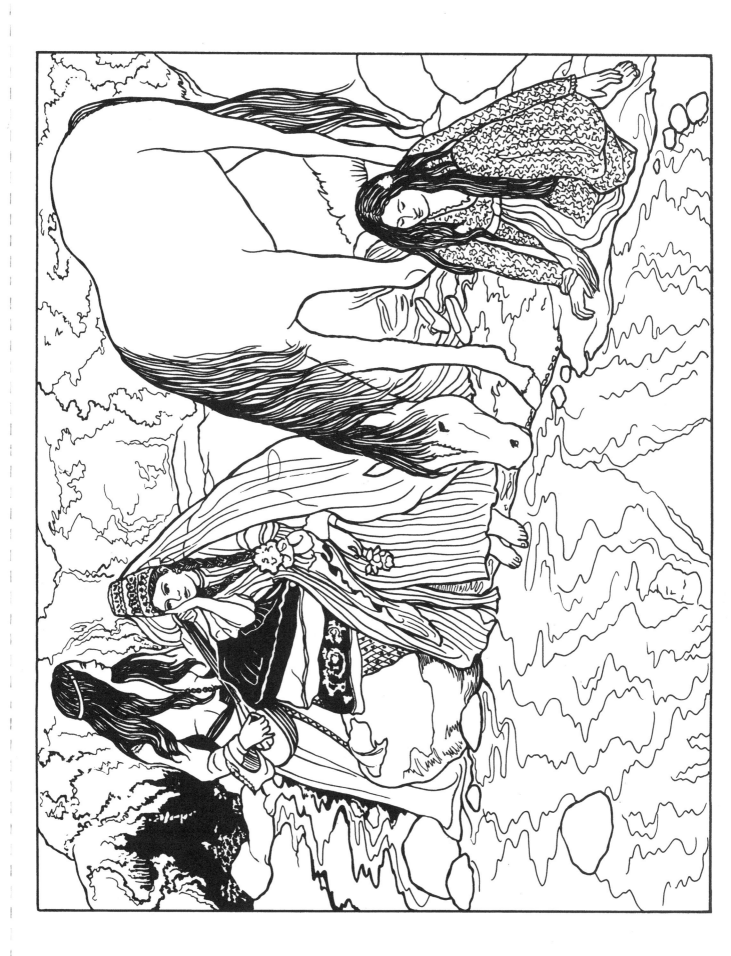

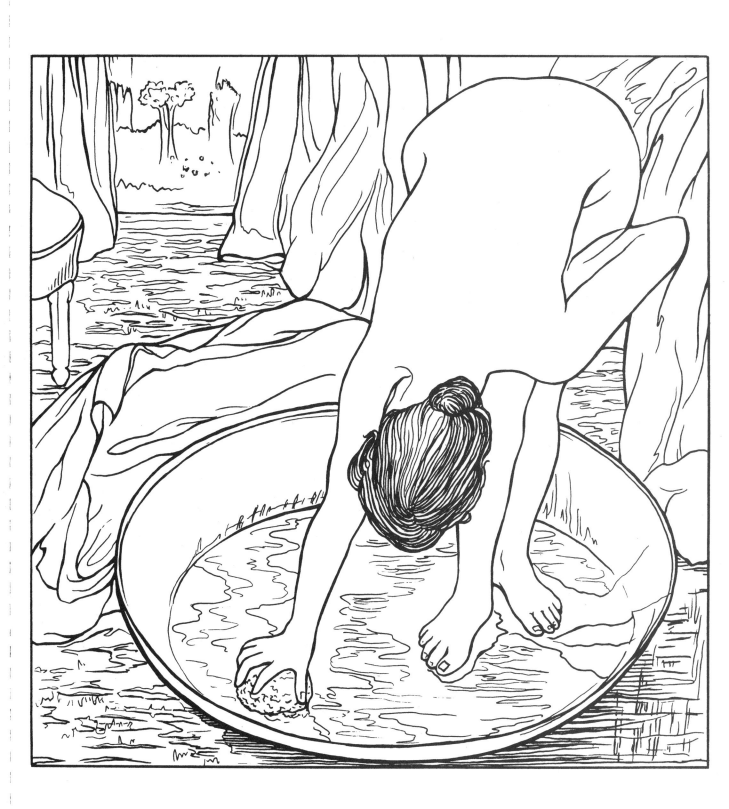

Degas created several images of women bathing for the last impressionist show, held in 1886. In all of these works, the woman's face remains hidden as if the viewer has stumbled upon her unnoticed. Although the subject is intentionally ambiguous, the small tub, called a cuvette, marks her as a member of the lower class.

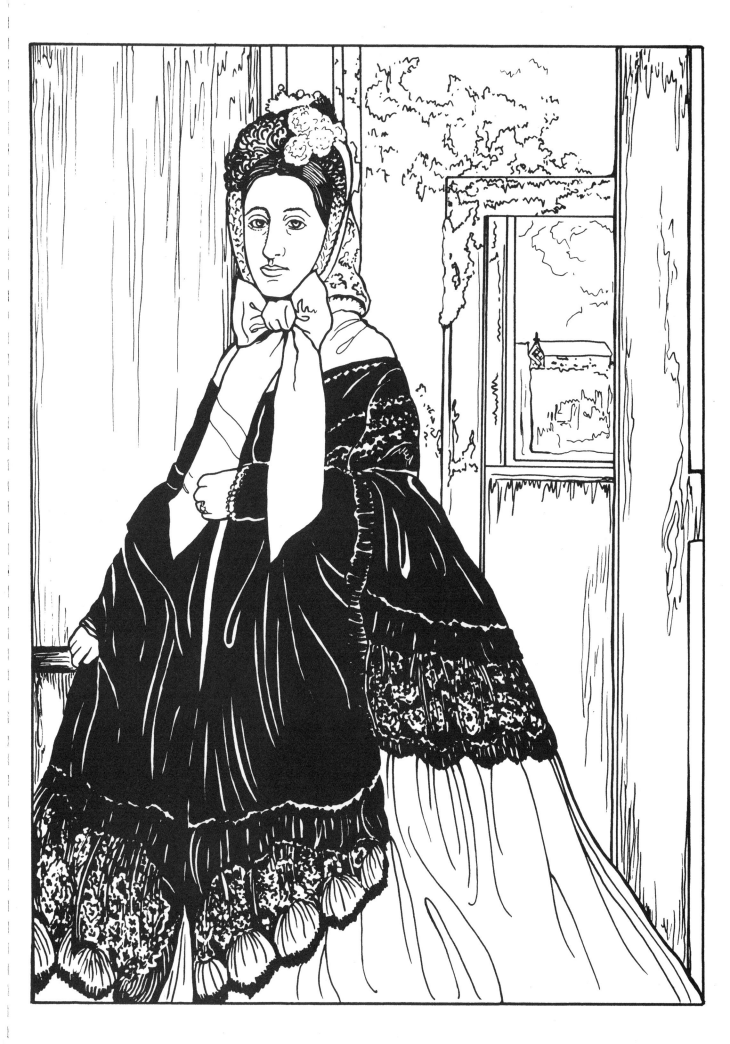

Plate 27
EDGAR DEGAS (1834–1917)
Portrait of Thérèse De Gas, **1863**
Oil on canvas.

This work features the artist's sister, Thérèse De Gas, shortly before her marriage to Edmondo Morbilli, a nobleman from Naples. Her anxious expression, and the fact that she is wearing traveling clothes, indicates that she may have been preparing for her journey to Italy.

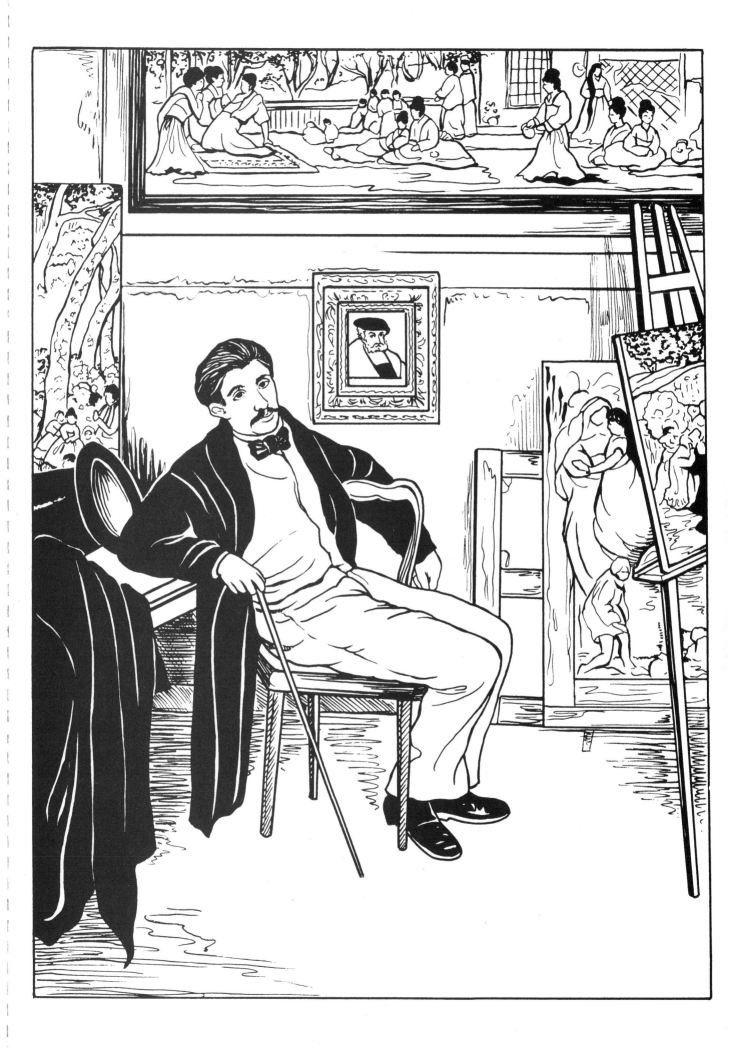

Plate 28
EDGAR DEGAS (1834–1917)
Jacques Joseph (James) Tissot, 1866–68
Oil on canvas.

Degas met the painter James Tissot in the 1850s while copying old masters at the Louvre, and the two men would remain friends for many years. Like Degas, Tissot enjoyed many different art forms and styles. Degas painted him here surrounded by a variety of works—a Japanese-style print, contemporary scenes from the sixteenth or seventeenth century, and a copy of Louis Cranach the Elder's *Frederick the Wise.*

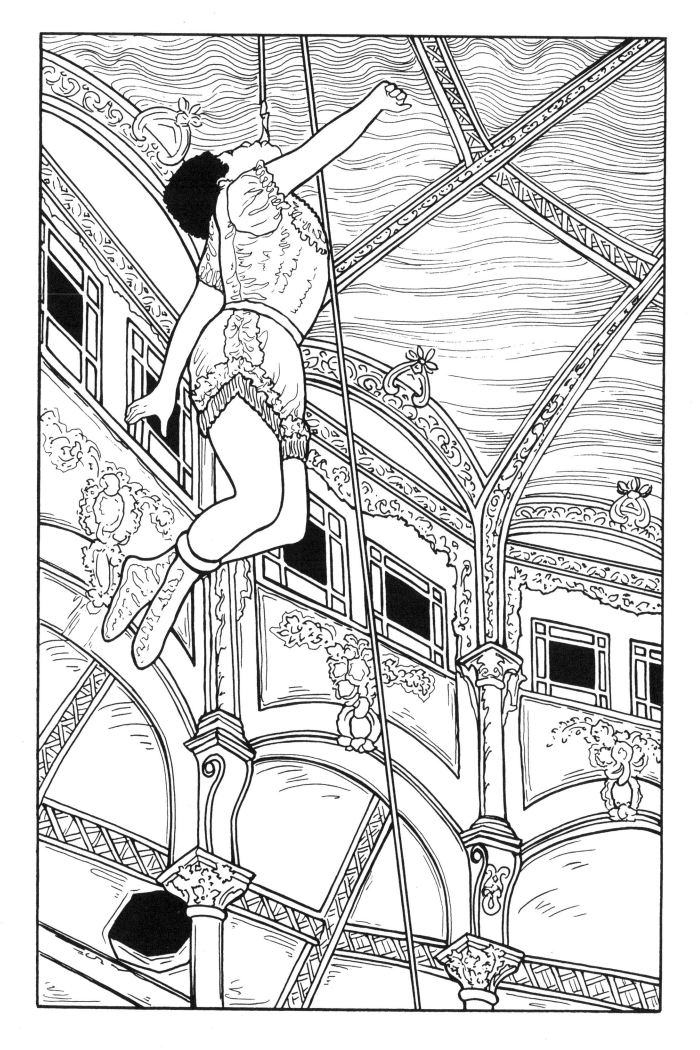

Plate 29
EDGAR DEGAS (1834–1917)
Miss La La at the Cirque Fernando, 1879
Oil on canvas.

Degas attended several performances of the Cirque
Fernando when it came through Paris in 1879. The star
of the show was the acrobat, Miss La La. For her final act,
she was lifted 70 feet into the air by her teeth! This scene
likely appealed to Degas due to his penchant for unusual
movements and angles.

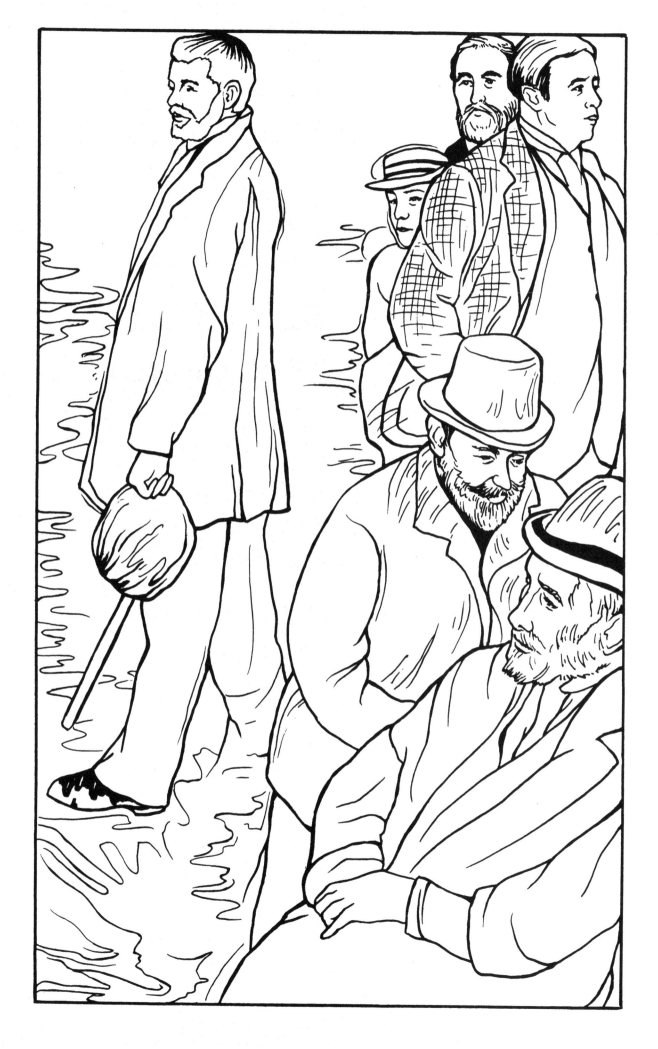